Those Early Years

Gertrude Vanderbilt Whitney Conner

Those Early Years

TURTLE POINT PRESS

TURTLE POINT PRESS

COPYRIGHT © 1999 BY GERTRUDE VANDERBILT WHITNEY CONNER

ISBN 1-885983-42-5 LCCN 98-061671

DESIGN AND COMPOSITION BY WILSTED & TAYLOR PUBLISHING SERVICES

PRINTED BY PHELPS/SCHAEFER LITHO-GRAPHICS COMPANY, INC.

IN THE UNITED STATES OF AMERICA

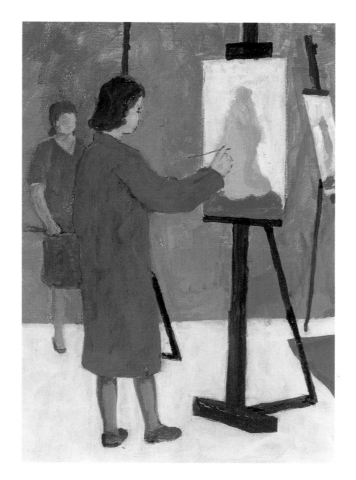

When I was seven the trees reached the sky. I ran under the tall trees through the cool shadows. Mademoiselle ruled my little world with lavish affection and I saw that I could have my way with her.

She would quickly punish my little house guest when I said he would not play nicely. I was an expert tease and a fast runner, so that I was always just out of reach! Mademoiselle waited with lemonade and cookies.

The long summer afternoons passed so happily.

The next summer I was given my own colt. I did not want him gelded. With my crop and an ever ready supply of sugar lumps, I soon had him so docile that he would trot and prance to my command.

I was getting used to having my way. Even Larry the groom admitted that he was impressed!

When fall arrived, I would visit my grandmother in her dark house on Fifth Avenue.

We walked in the park and took drives in her magical car. Then we had tea and tiny sandwiches. I dreamed about her distant world of art and music, of ocean liners and horse races.

Would I ever be a part of it?

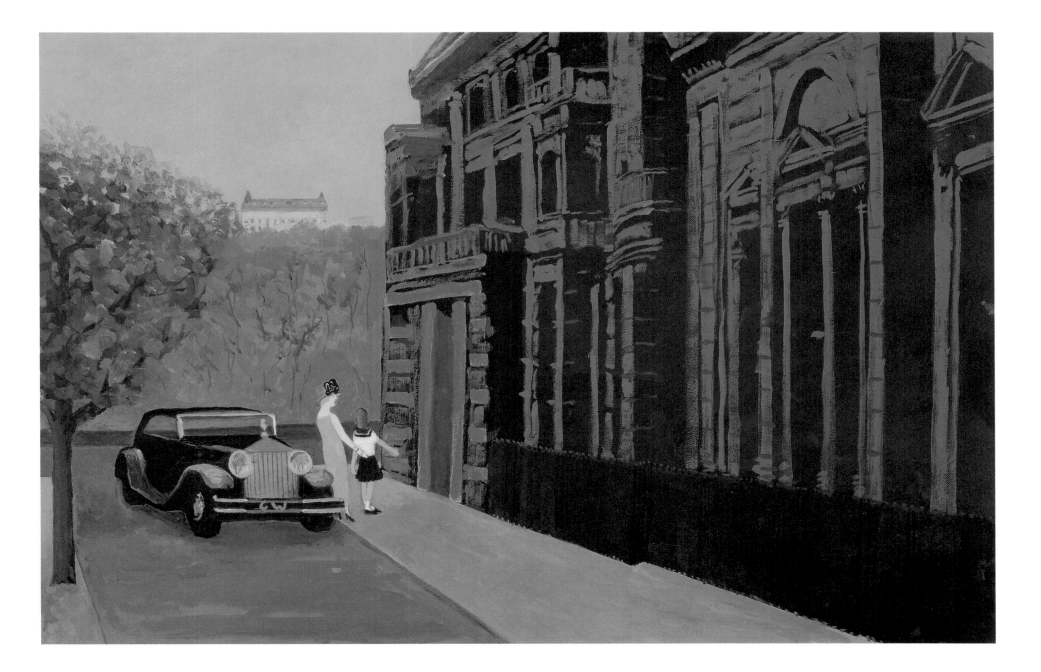

Julys the family sailed along the coast of Maine on my father's white yawl. It was often stormy and foggy and grey.

When I heard the moaning of the stays I was afraid of letting go. But then all of a sudden the sky would clear and little islands would appear, bright and shining. Down went the anchor in a protected cove.

In my bunk I would read <u>Little Women</u> and listen to the grownups on deck talking and laughing.

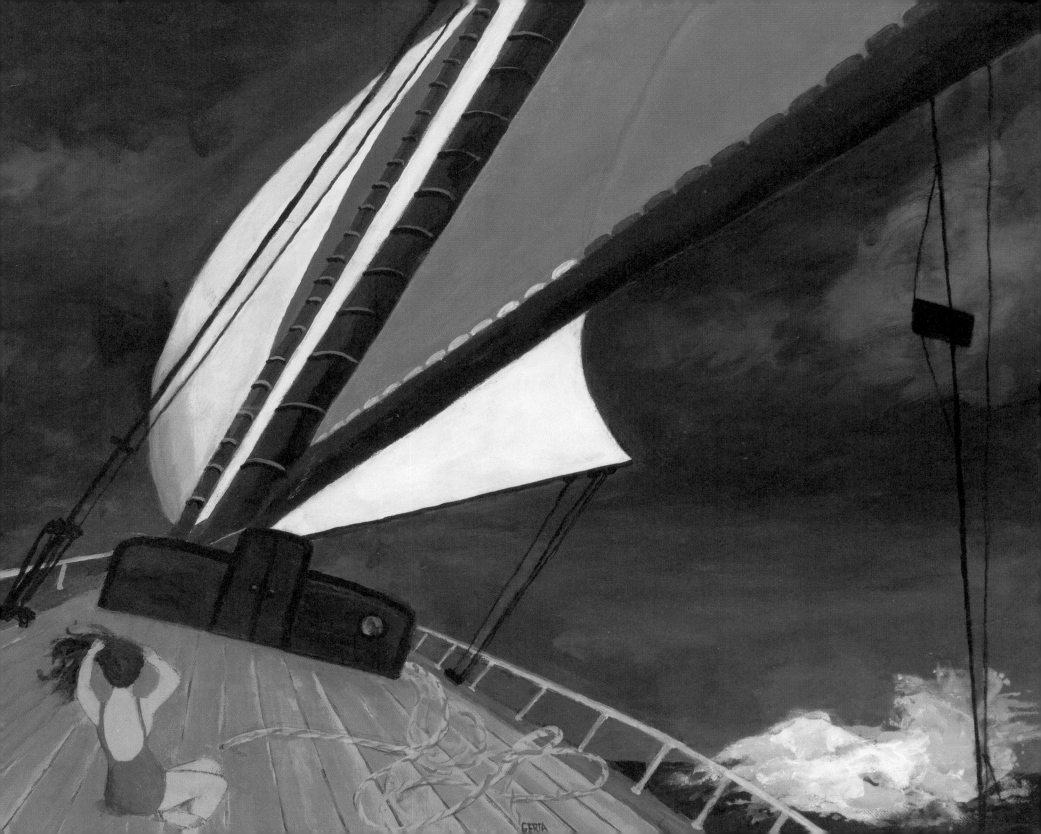

Augusts we settled in the family's Adirondack camp. I loved the pine-scented days and the crisp nights and the deep colors of the North Woods.

I tried to master the skills of fly fishing with silken line, to capture the free and flashing trout.

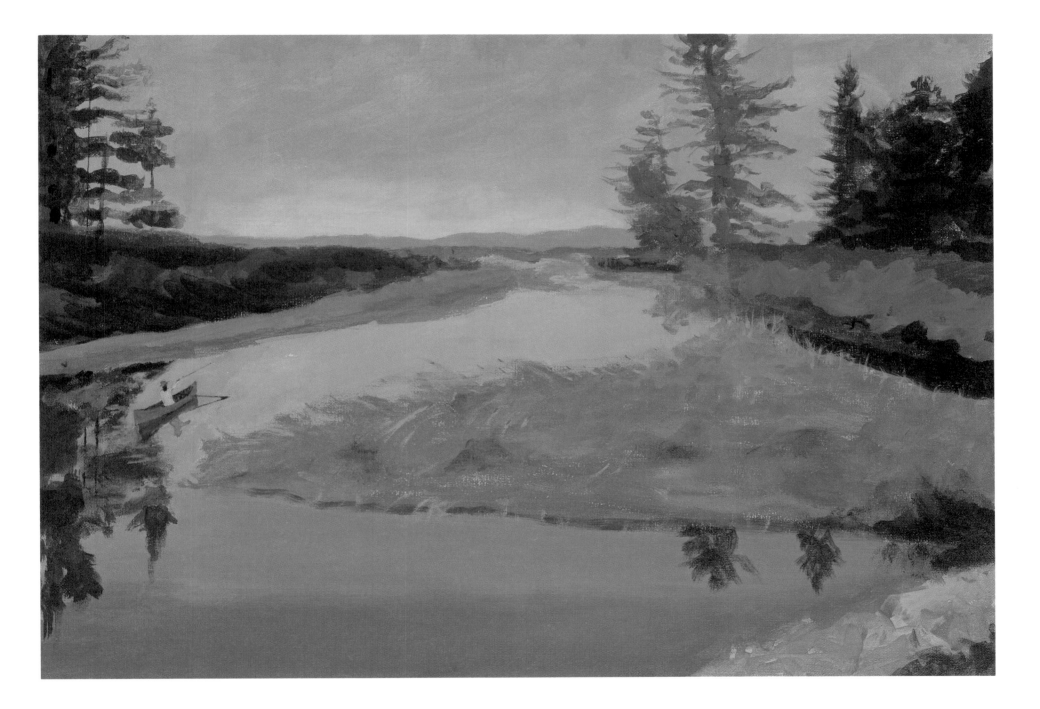

When I was sixteen, I increasingly sensed the wild and untamed wolf within me.

I imagined that the wolf was transported into a laughing woman who ran free.

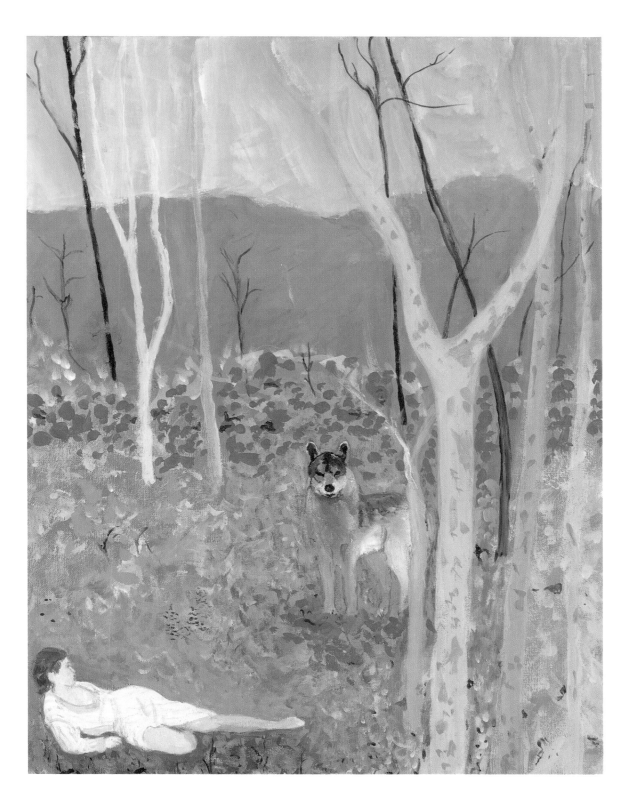

Then I met a glamorous Peruvian. I was entranced and soon hopelessly in love — longing for adventure and escape from girlhood.

We married and settled in New York. I was seventeen.

My parents seemed increasingly preoccupied, but an old childhood friend was always there for support.

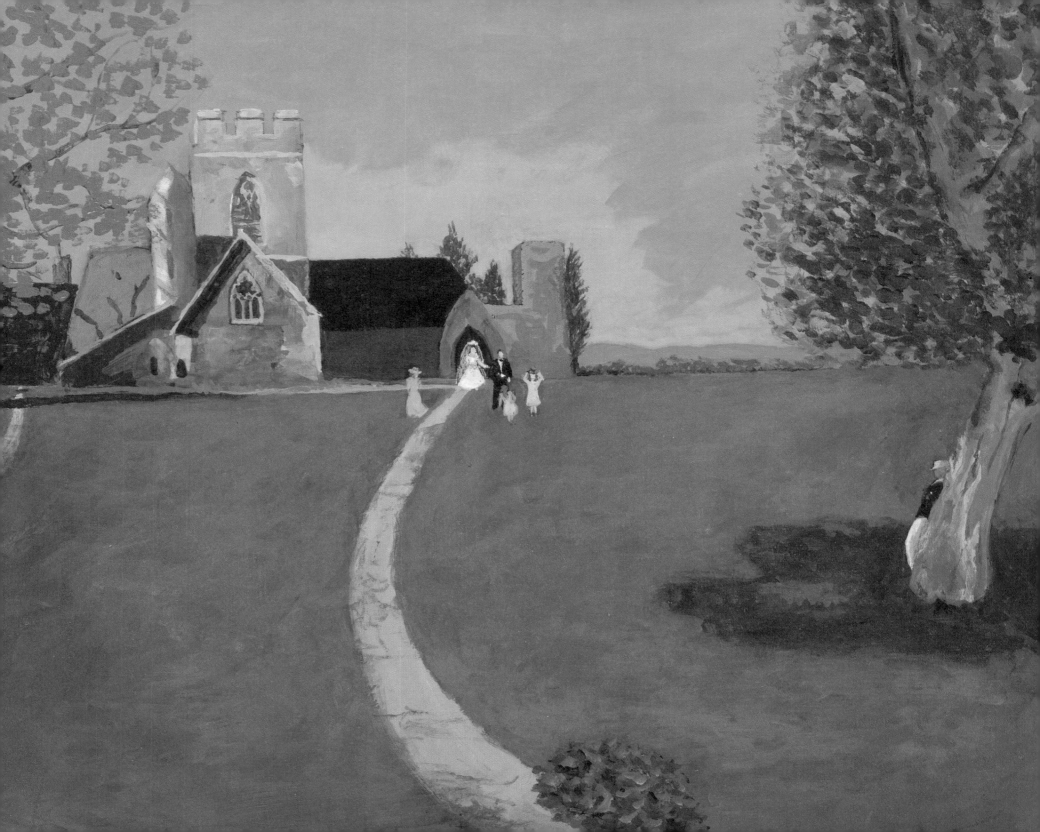

Marriage was like playing house but with constant parties.

Our daughter was born and life seemed full at last. Who is really prepared for the experience of a first baby? In time everything became natural and real.

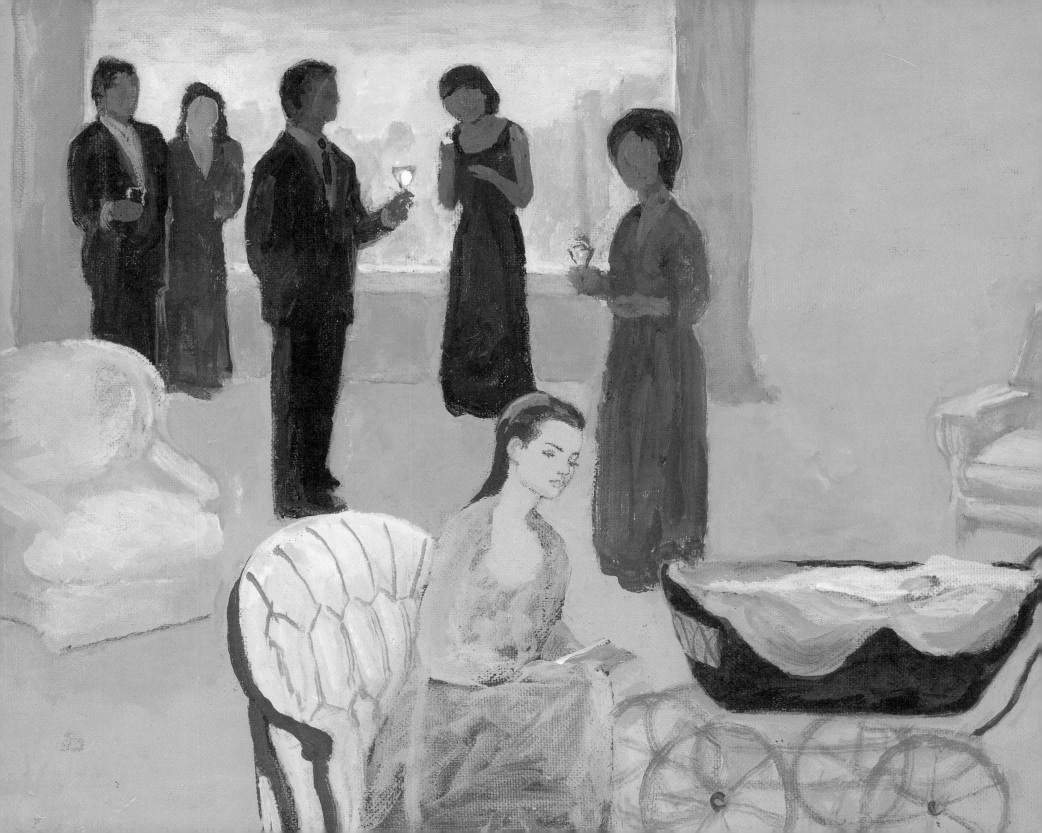

All of a sudden my husband was called to Peru on business. It was terrifying to leave all that was familiar.

On a cold blustery day, we sailed out of New York Harbor — the three of us — for a faraway place, a world that was completely unknown to me.

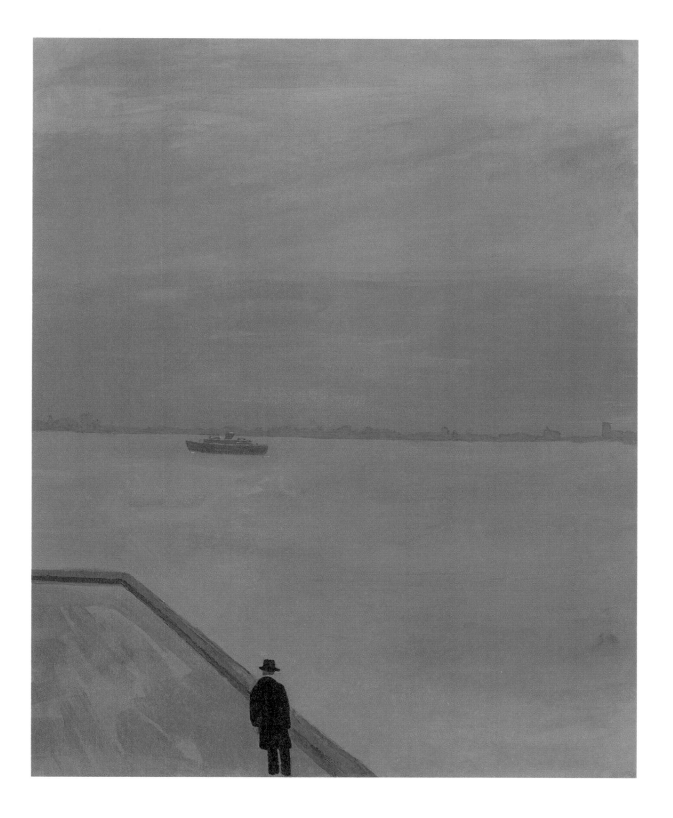

From the very beginning Lima was difficult. The society seemed distant, rigid.

Our big white house was walled in and planted with very old boxwood. The servants were always near.

With Spanish lessons I became fluent and I was gradually accepted. The closed social world opened up.

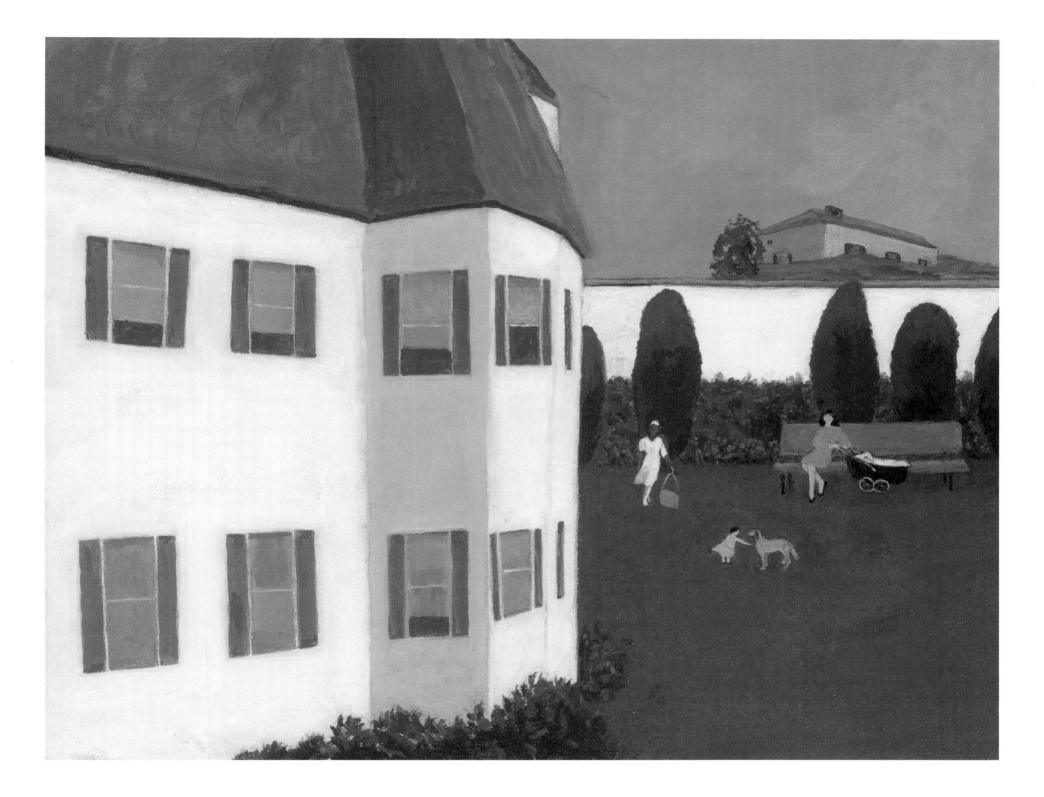

My son was born, and with our wonderful nurse the children flourished.

But there was a chill in the marriage, though I didn't understand it.

One afternoon when I returned home from a luncheon, the children and the nurse were gone. Many of their things had been packed up. Barbara was three years and his four months.

I was alone in the large and silent house.

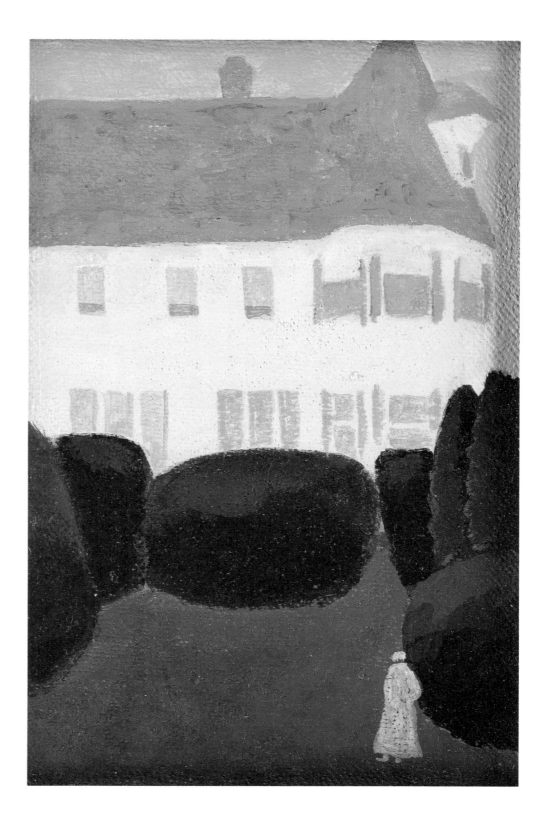

A week later I retained a lawyer and within a few months my case came before the Superior Court.

Waiting outside the Court house, my lawyer explained the intricacies of Spanish law, which would determine the hopes and fears of my future.

A decision was reached. The judge ordered my husband to return the children.

The police were ordered to look for them.

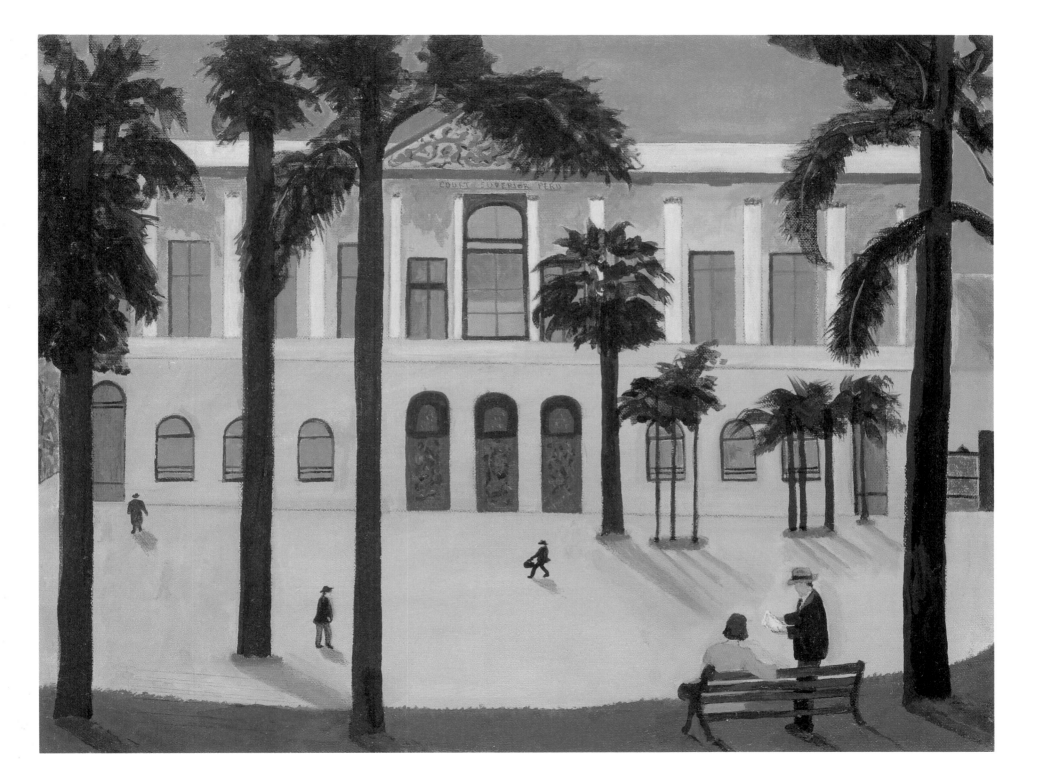

Hours after the court ruled, I was warned that the children were to be taken out of Peru by air.

I rushed to the airport and watched helplessly as the plane took off.

In tears, I knew I was alone.

Lost children...o!

One court said they were hers—but she hasn't
seen them since their spectacular 'kidnaping'

An old friend of the bride's family smiled tremulously as the couple walked down the church steps, dabbed at a typical wedding tear with a bit of lavender lace, and sighed:

"A perfect match!"

And so it was, for a while. A match that burned beautifully bright and searingly hot for thousands of hours before it began to sputter and die. Dying, it ignited a series of emotional explosions that wrecked a home, precipitated international complications and made puzzled pawns of two little children.

Gertrude Vanderbilt Whitney Henry and ⸻baldoni had everything in their favor ⸻ were married that crisp January ⸻ New York's fashionable Epis-⸻t. Bartholomew's.
⸻h and beauty, Gertrude ⸻d social position and

had come to New York from Peru as a commercial attache of the Peruvian consulate. His father was head of the National Discount Bank of Lima and proudly served as his son's best man at the wedding.

The newlyweds went on a honeymoon fitting their means and position. It ⸻, spent in Florida and ⸻ they returned to New York to se⸻ await the birth of their first ch⸻ for a boy who would dev⸻ yachtsman like her b⸻ Luis wanted a dau⸻ baby was christ⸻

Two years ⸻ birth ⸻ friends ⸻ match ⸻

I had come to love living in Peru but now my life was in shambles.

Desperately needing help, I found a well-respected psychiatrist and began treatment four times a week. In a year and a half he led me to a deep understanding and acceptance of myself.

He convinced me, against my will, that I must leave Peru and return to my own roots.

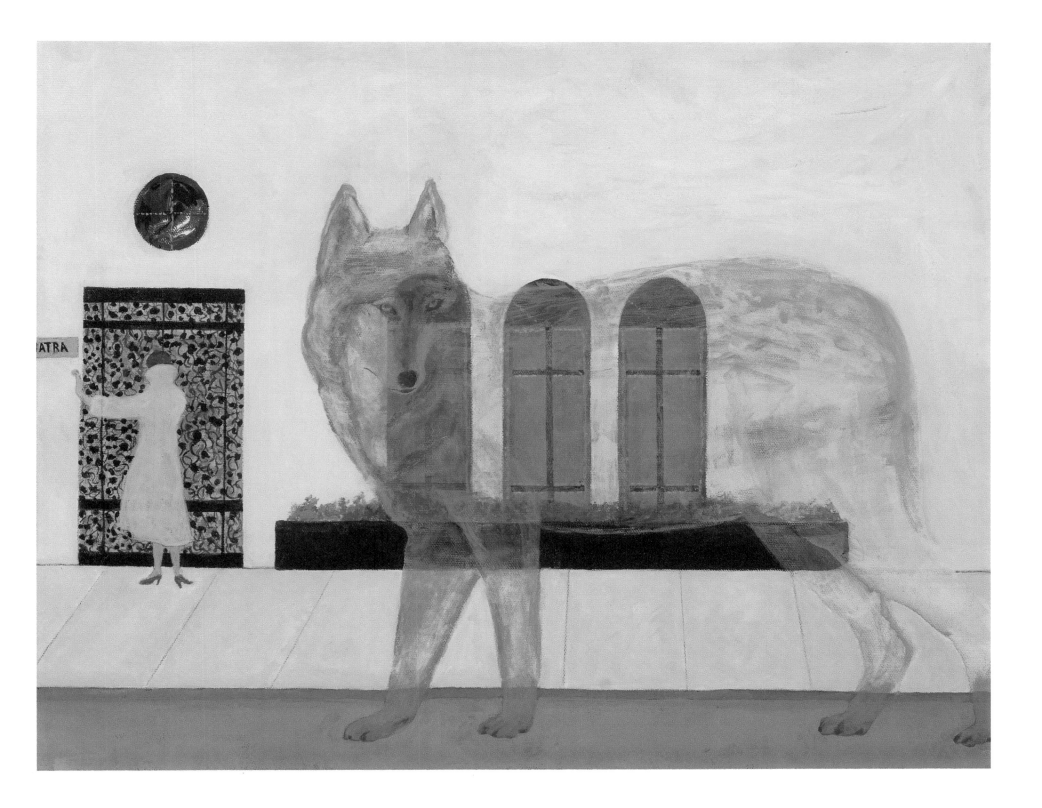

Back to New York after so long away. I found a nice apartment and quickly bought an Abyssinian cat. But nothing could help me escape from my alone—ness.

Old friendships were revived. With ponderous lawyers, I set upon the task of finding my husband and my children.

They were in Spain, but exactly where we couldn't discover.

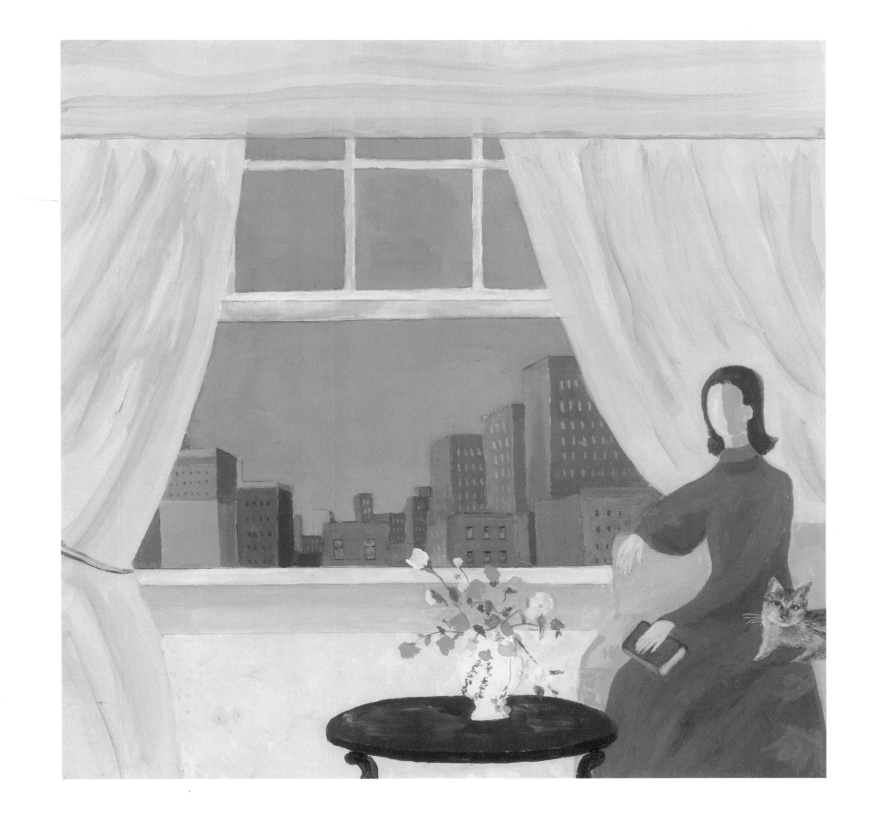

I decided very soon to return to life-drawing classes at
The New School.

With four full days a week, I was absorbed with the
truth and beauty of a simple line. Then I started painting and
my work became the focus of my life.

It wasn't long before I sold my first painting. Fears and
doubts vanished like a lifting fog off the coast of Maine.

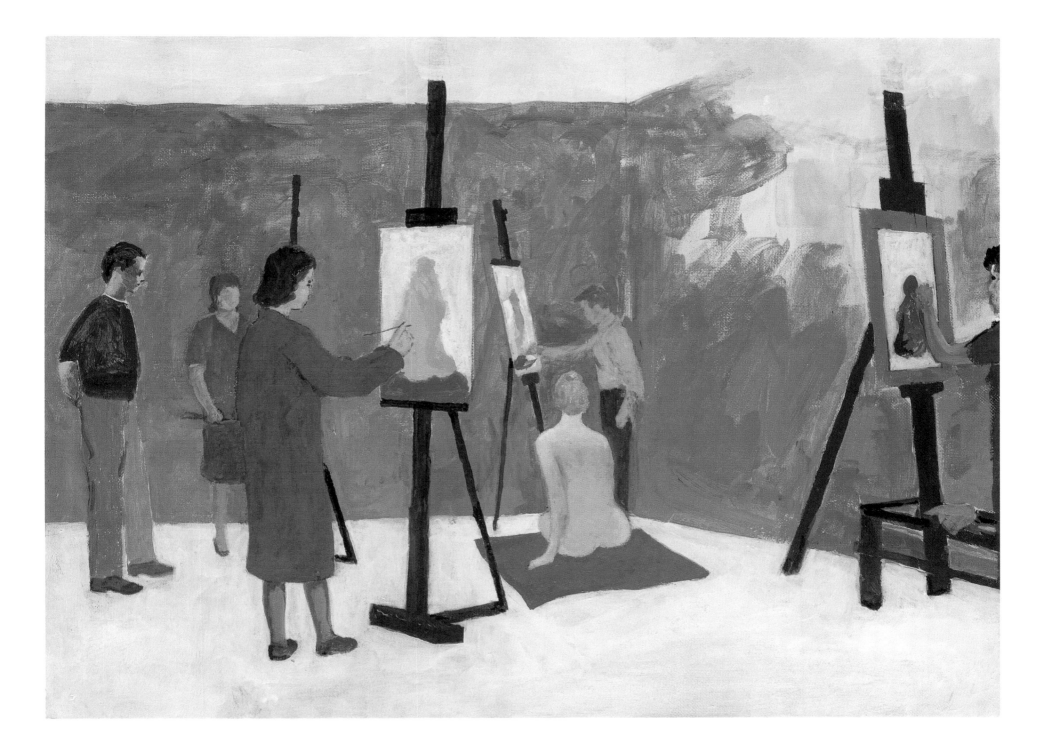

Now twenty-five years old, I made new friends.

The place to meet and be at night was El Morocco.

Many evenings I would be dining and dancing the hours away.

Was there really any other place to be?

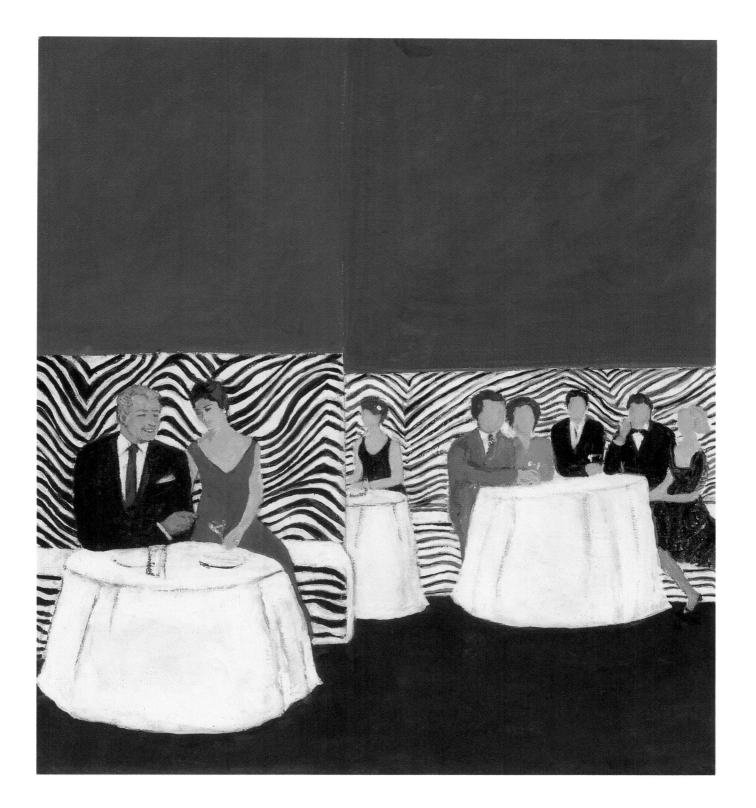

fighting my way toward a reunion with my children — fulfilled in a lovely little studio — secure in a blessed circle of friends and a wildly diverse family — more and more I could return to my roots.

Long stretches of beaches in the south became perfect vacations.

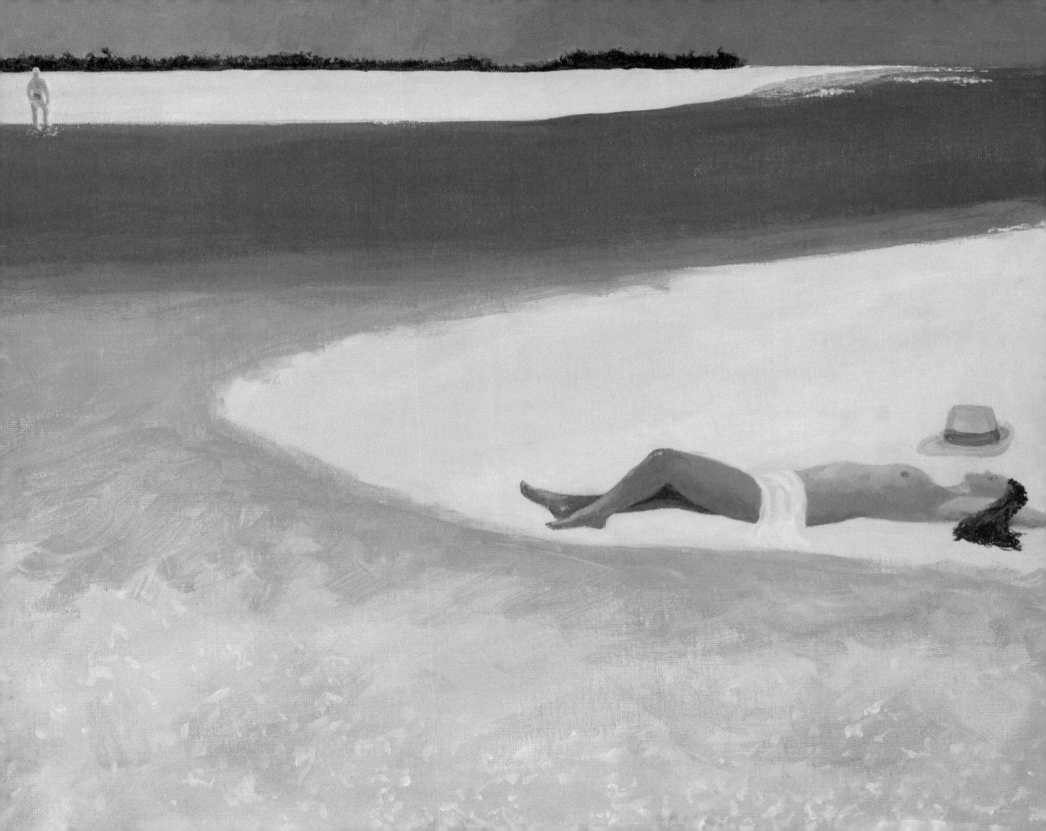

I stopped by the place where I grew up. Some of my favorite trees, tall and proud, were there still - perhaps a bit ashamed to be seen when so many were lost to developers. But most of the tall trees that reached the sky were only a memory.

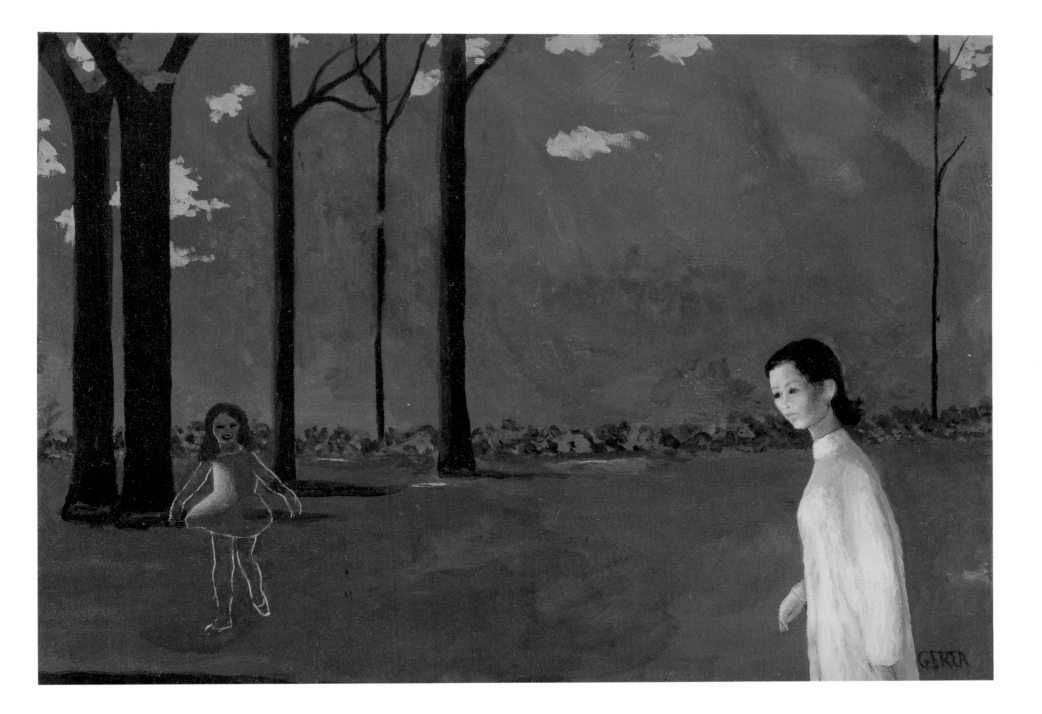

Epilogue

Because my husband was able to move about with the children, it was years before I saw them again.

My son was sixteen when he contacted me and we were able to get him to this country.

My daughter came when she was twenty-four.

At last we were together.

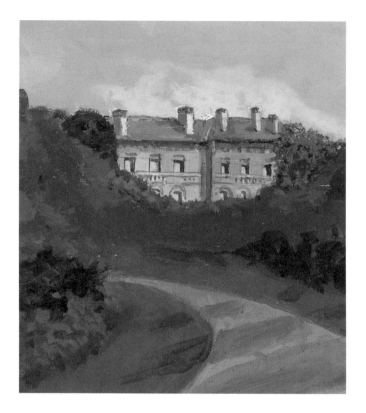